# Flowers in Oils

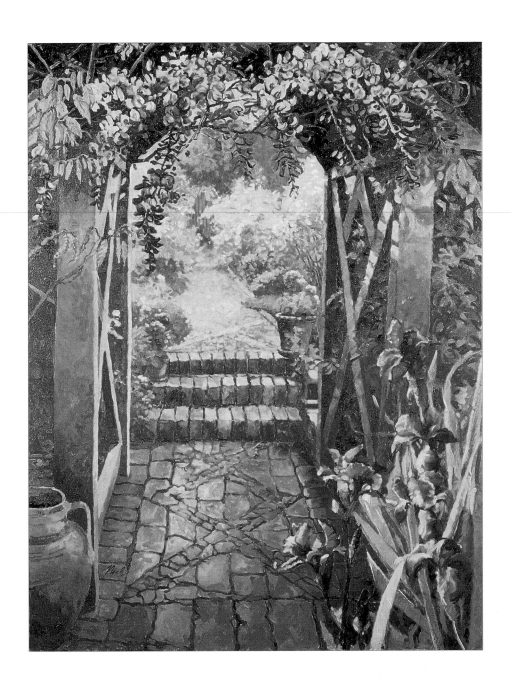

# Flowers in Oils

## NOEL GREGORY

SEARCH PRESS

First published in Great Britain 2001

Search Press Limited
Wellwood, North Farm Road,
Tunbridge Wells, Kent TN2 3DR

Text copyright © Noel Gregory 2001

Photographs by Search Press Studios
Photographs and design copyright © Search Press Ltd. 2001

ISBN 0 85532 852 5

The Publishers and author can accept no responsibility for any consequences arising from the information, advice or instructions given in this publication.

The publishers would like to thank Winsor & Newton for supplying many of the materials used in this book.

Suppliers
If you have difficulty in obtaining any of the materials and equipment mentioned in this book, then please visit the Search Press website for details of suppliers: www.searchpress.com

Alternatively, you can write to the Publishers at the address above, for a current list of stockists, including firms who operate a mail-order service, or you can write to Winsor & Newton requesting a list of distributors.

Winsor & Newton, UK Marketing
Whitefriars Avenue, Harrow,
Middlesex, HA3 5RH

Publishers' note All the step-by-step photographs in this book feature the author, Noel Gregory, demonstrating his oil painting techniques. No models have been used.

There is a reference to sable hair and other animal hair brushes in this book. It is the Publishers' custom to recommend synthetic materials as substitutes for animal products wherever possible. There is now a large number of brushes available made from artificial fibres and they are just as satisfactory as those made from natural fibres.

Colour separation by Graphics '91 Pte Ltd, Singapore
Printed in Spain by A. G. Elkar S. Coop. 48180 Loiu (Bizkaia)

*I would like to thank so many of my friends who have supported me through many years of art development, including everybody in Farnham Common, Buckinghamshire, who knew my gallery and made it such a good memory.*

*Special thanks are due to my early patrons, Noel and Rosy Wicks, and Paul and Ann Smith, without whose encouragement the journey would have been harder.*

*I would also like to mention the invaluable help that David Messum showed me in my early days of picture dealing – his entrepreneurial spirit inspired me to stay the course through difficult times. My life has been enriched by people like these.*

Page 1
Wisteria Arch
*Size 760 x 1015mm (30 x 40in)*
*Wisteria is a favourite plant of mine to grow as well as to paint. This composition was created from several photographs using the method shown on pages 18–19.*

Pages 2–3
Rhododendron
*Size 760 x 570mm (30 x 22°in)*
*I also love painting rhododendrons. This painting of a composite collection of flowers uses equal amounts of warm and cool colours to give it interest and, although it has no composition, structure or perspective, it is a balanced picture. Paintings like this can be developed by starting in one corner of the canvas and adding/moving shapes about as you build up the picture. It means that you have to bring various flowers into the studio and let the composition develop as you proceed. The out-of-focus background was created using a clean dry brush (see page 25).*

Opposite
Hollyhock Cottage
*Size 760 x 610mm (30 x 24in)*
*This painting was created from a photograph in a magazine. The hollyhocks and foxgloves in the foreground were taken into the studio and painted from life. I wanted to emphasise the light coming through the trees and flowers, so I purposely subdued the cottage with a pale blue wash.*

# Contents

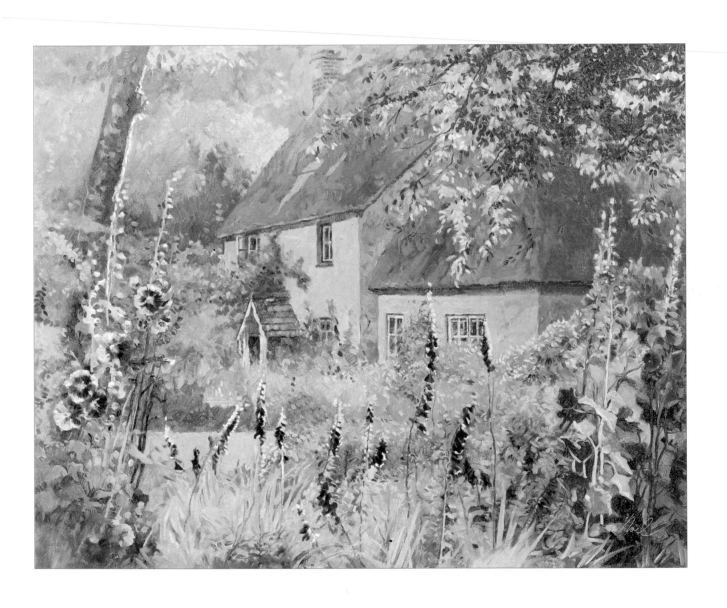

# Introduction

I often hear the words 'If only I could do that', 'I wish I had the talent for painting' or, more often, 'I can't even draw a straight line'. Let me tell you something – I cannot draw a straight line nor, I might add, would I want to. Painting pictures is not about talent or an extra gift given at birth; it is about work and tenacity, making mistakes, being able to recognise them and trying to correct them. Painting, I have found, is often about sudden advancement. Just as you think of never being able to improve, you produce a work that far outshines anything you have done before, and off you go again. While teaching adults earlier in my career, I was responsible for many hundreds of beginners, and I never found any who did not improve with persistence. You only have to want to do something, then, with the proper tools and encouragement, you can begin the greatest adventure of your life.

*Garden Foxgloves*
*Size 405 x 290mm (16 x 11½in)*

*This painting shows how a picture can be formed by setting up your easel next to almost any spot in the garden. Here, the sunlight creates good tonal contrasts in the composition. Without this strong light source the subjects would have been flat and uninteresting. Remember that mastering tone is paramount for a good painting – light against dark, and dark against light – and that your skills of drawing and the use of colour are of secondary importance.*

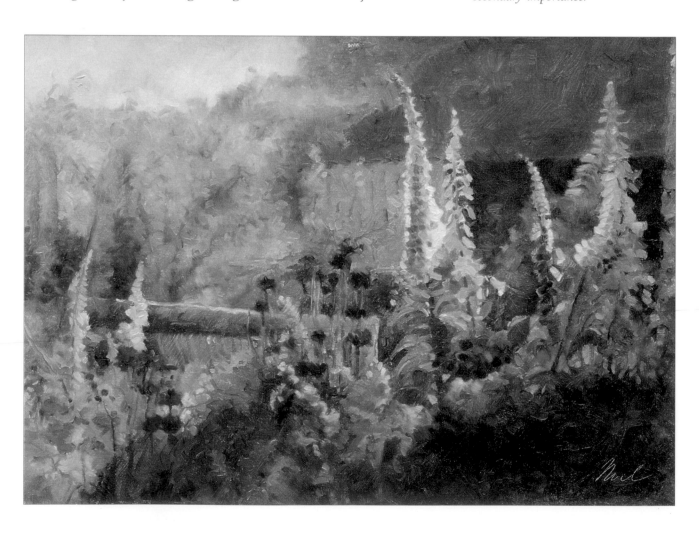

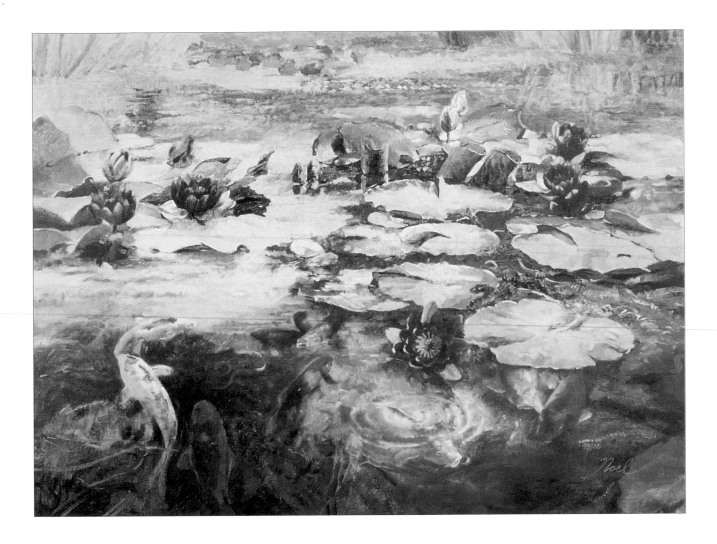

**Goldfish and Water Lilies**
*Size 1015 x 760mm (40 x 30in)*

*This type of subject is a particular favourite of mine. It is not strictly a painting of flowers, but the addition of water lilies is of significant importance to this composition. They add colour and strength to the design, as well as interest, and the whole picture has benefited by their inclusion.*

So let me introduce you to what is one of my favourite subjects – painting flowers in oils. Flowers have excited artists for centuries: Dutch Great Masters painted them in extraordinary detail; early explorers took artists with them to reproduce, usually in watercolour I might add, the flora they discovered on their travels; and impressionists used flowers as an influence in their subject matter. Claude Monet's water lilies and Vincent Van Gogh's sunflowers have been reproduced so many times that few would not be able to describe them.

Flowers are the ideal subject for both the beginner and the advanced student. They can be painted without worrying about perspective and almost without regard to colour. They can be painted in the crudest manner or with great sensitivity. No matter how you deal with them, flowers always seem to end up looking like flowers.

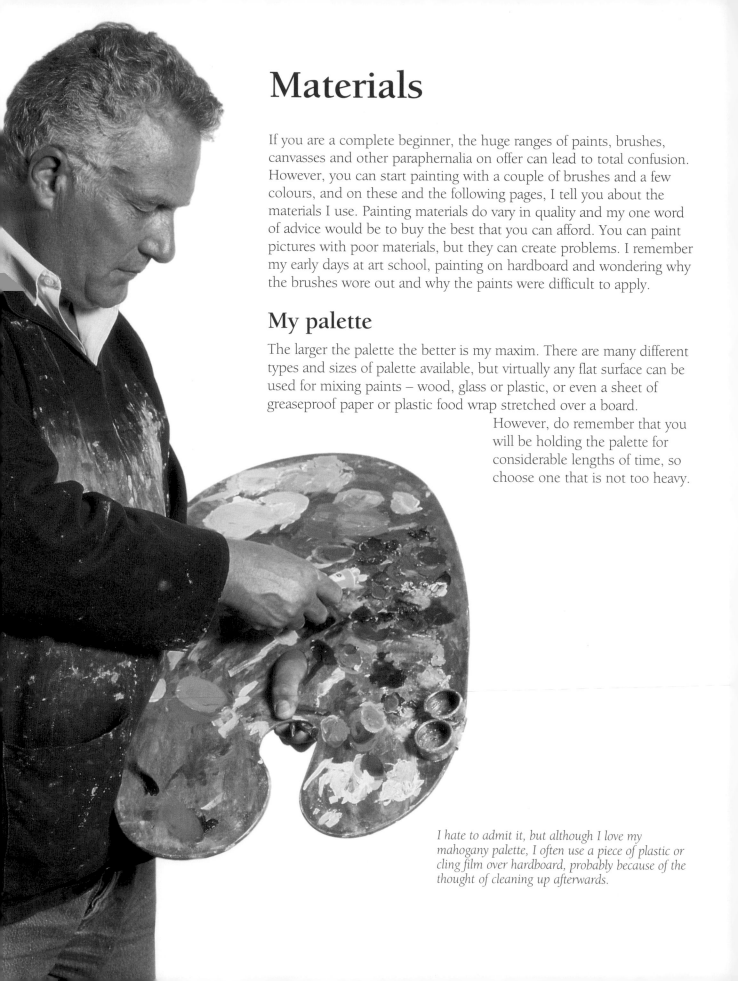

# Materials

If you are a complete beginner, the huge ranges of paints, brushes, canvasses and other paraphernalia on offer can lead to total confusion. However, you can start painting with a couple of brushes and a few colours, and on these and the following pages, I tell you about the materials I use. Painting materials do vary in quality and my one word of advice would be to buy the best that you can afford. You can paint pictures with poor materials, but they can create problems. I remember my early days at art school, painting on hardboard and wondering why the brushes wore out and why the paints were difficult to apply.

## My palette

The larger the palette the better is my maxim. There are many different types and sizes of palette available, but virtually any flat surface can be used for mixing paints – wood, glass or plastic, or even a sheet of greaseproof paper or plastic food wrap stretched over a board. However, do remember that you will be holding the palette for considerable lengths of time, so choose one that is not too heavy.

*I hate to admit it, but although I love my mahogany palette, I often use a piece of plastic or cling film over hardboard, probably because of the thought of cleaning up afterwards.*

Ivory black

Burnt sienna

Burnt umber

Cadmium red

Alizarin crimson

Cadmium orange

Cobalt violet

Cerulean blue

Ultramarine

Viridian

Cadmium yellow

Titanium white

## Paints

Paints vary considerably from brand to brand and each range usually includes different qualities of colour. Artists' quality are the best – they contain the highest grade and greatest quantity of pigment – but students' quality paints are more than adequate for the beginner.

You can start painting with just five colours (see pages 11–15), so find a range that suits your pocket and start with just a few tubes of colours. Then, as you gain in confidence, you can add more colours to your palette. My flower palette has the twelve colours shown here and I used these colours to paint all the projects in this book.

## Brushes

Brushes are the most personal of all artists' materials and can be the most expensive items in your workbox. They are made from resilient hog hair or nylon and come in four different shapes: flat, bright, filbert and round. It can take years to get familiar with all the different types and sizes of brushes that are available, so here I tell you about the brushes that I use.

My favourite brushes are brights, which have square flat ends to the bristles, and I used these to paint all the projects in this book. I suggest having three or four sizes, ranging from size 6 to size 12, and one large flat brush for blending (this could be a 40mm (1½in) decorator's brush.

I use sable hair round brushes for drawing and for adding finishing touches to a painting, and I recommend using sizes 1 and 3.

Look after your brushes and never allow paint to dry on the bristles. Clean them with white spirit, then washing-up liquid, working the bristles in the palm of your hand. Store brushes in a jar (with their bristles upwards) or flat in a drawer. Brushes do wear out but, even when only a fraction of the original bristle length remains, they can still be used for drawing.

## Surfaces

There is no substitute for a good quality linen canvas, but I must not underestimate cotton canvas and canvas board, for they each have their uses. Their texture and weave produce different paint effects and, obviously, you would not want to paint fine detail on a rough textured surface.

You can produce cheap painting surfaces by priming cotton sheeting or sailcloth with oil bound primer. You might also consider using sheets taken from one of the many oil sketching pads available. These can be mounted on cardboard or thin plywood to provide an excellent inexpensive surface.

## Easels

I always use an easel, as it is not easy to paint with a canvas on your lap. Again, there are lots of different types to choose from, but lightweight, adjustable wooden sketching easels can support very large canvases.

## Mediums

Linseed oil and turpentine (or white spirit) are the best known painting mediums. I use linseed oil to thin my colours and white spirit for cleaning up after a painting session.

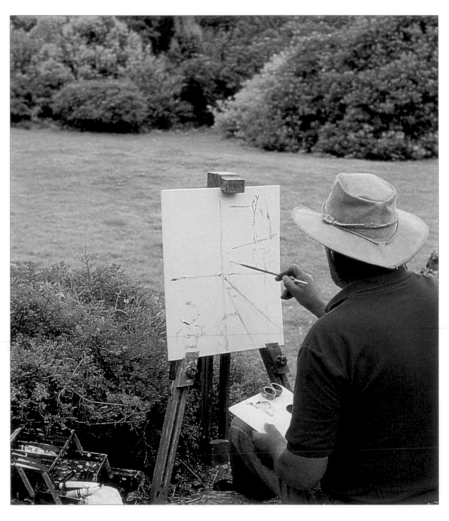

There are many special preparations to be found in art shops but, once gain, I suggest you gain confidence with the basics before considering the alternatives.

You can buy small containers for mediums that clip on the palette. I favour the type that has two wells, side by side.

# Mixing colours

Having bought your materials, the next stage is to familiarise yourself with colour. We all have our favourite colours but, since none of us know what hues each other sees, it is best to describe colours as being either hot or cold. In simple terms, reds are hot and blues are cold.

A great deal can be learnt by mixing colours on your palette. In theory, the three primaries, red, blue and yellow, should produce all the colours of the spectrum. However, in practice, you will often have to add other colours to create a full workable range.

To help you get to grips with colour mixing, try painting two simple abstract designs as shown on the following pages; one with just cool colours, the other with warm ones. For these examples I used alizarin crimson, cadmium yellow and ultramarine as my primary colours and titanium white and ivory black to add tones.

When you have finished both exercises, put them together and note the difference in mood and perspective.

*Alizarin crimson*

*Ultramarine*

*Cadmium yellow*

*Titanium white*

*Ivory black*

*These five colours were used to create the abstracts on pages 12 and 14.*

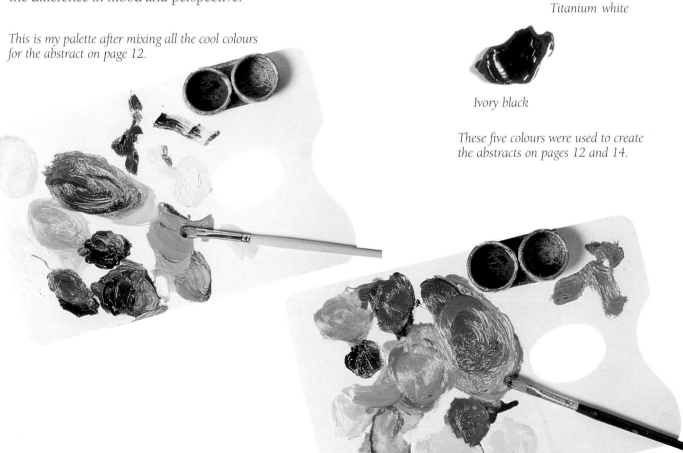

*This is my palette after mixing all the cool colours for the abstract on page 12.*

*This is my palette on the completion of the warm colour abstract on page 14.*

# Cool colours

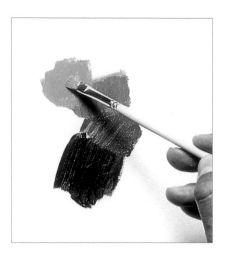

For this experiment the predominant colours used for mixing are blue and yellow. White and black, and tiny spots of red, are added to mixes to create subtle changes of tone.

First mix the blue with a little linseed oil, then paint a mark on the canvas. Gradually add a touches of yellow to the mix to make a range of greens, then add blocks of these colours to the canvas.

Now, adding white and yellow, work up a range of paler tones, then add these randomly around the previous marks.

Add touches of red to the mixes on the palette to create cool browns, then gradually strengthen the mixes with blue and yellow.

Finally, add touches of black and white, to make dark and light tones and paint blocks of these on to the canvas.

Continue building up the abstract design with subtle changes of tone, by mixing together all the various tones on the palette. Notice how many tones of green you can make.

12

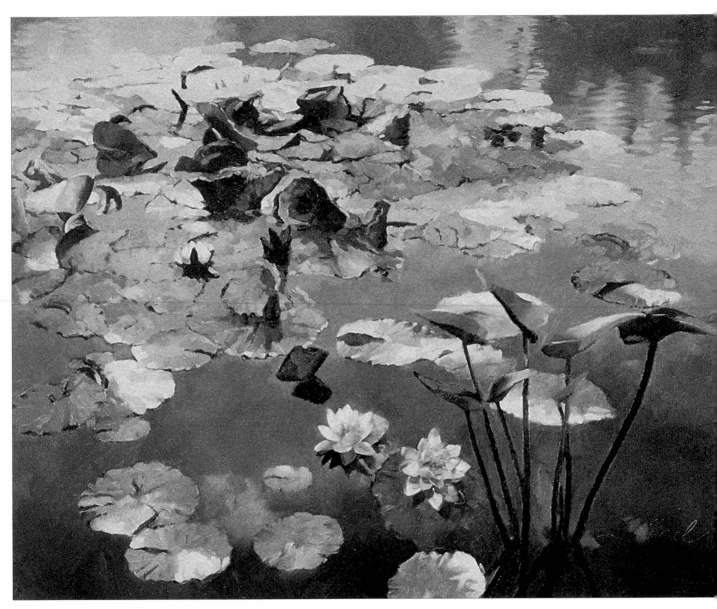

**Lily Pond** (cool colours)
*Size 925 x 760mm (36½ x 30in)*

*I used the five basic colours listed on page 11 to paint this tranquil scene. However, I also added viridian (a cool green) and monestial blue to enable me to produce a wider range of colours found in the cool end of the spectrum.*

# Warm colours

Now use the same five colours to create an abstract painting with tones from the warm end of the colour spectrum. This time, the predominant colours are red and yellow with the blue, white and black being added to create subtle variations of tone.

Start by laying down a block of red, then gradually introduce white to the palette to make paler tones.

Next, add touches of yellow to the mixes on the palette to create a range of orange tones. Lay in random blocks of these colours around the previous marks.

Now add tiny touches of blue to create warm browns, then add yellow (and white) to create pale tones, and touches of black to make darker tones.

Continue making more subtle changes to the mixes on the palette, then add these tones to the design until you have covered the canvas. Again, notice just how many different colours you can create.

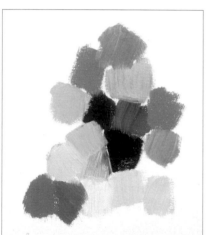

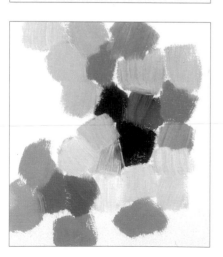

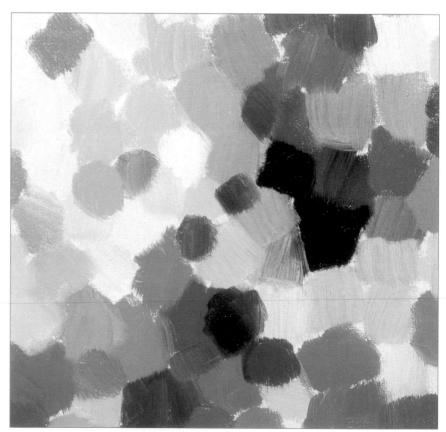

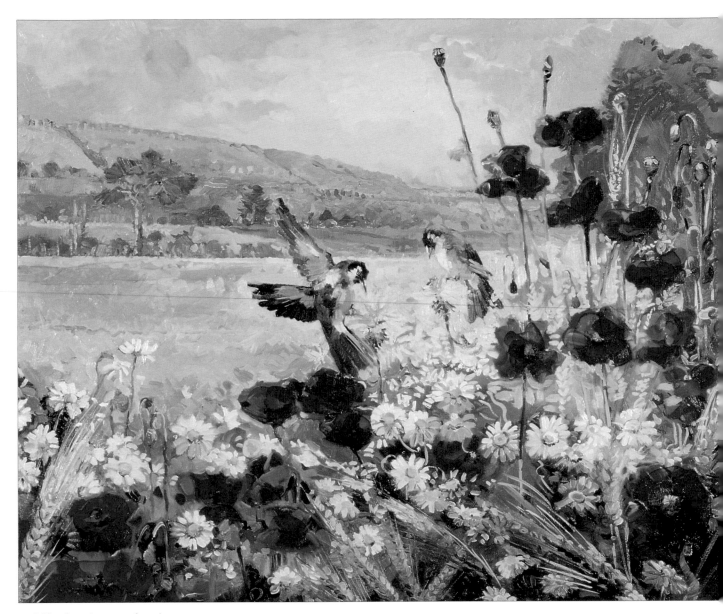

**Goldfinches** (warm colours)
*Size 925 x 760mm (36½ x 30in)*

*The goldfinches are the focal point in this picture, and their bright plumage dictated the colour range for the flowers and landscape. The result is a blaze of hot, midsummer tones. Depth is created by using warm tones in the foreground and cooler ones in the distance. The subdued background colours have been cooled down by adding white to the warm mixes.*

# Choosing a subject

When painting landscapes, composition is of paramount importance, and you often have to add objects to a scene to make it more interesting. On the other hand, if you choose to paint flowers, the subject really dictates how you paint it. Most of my flower studies are painted *in situ* or as still-life arrangements in my studio. However, I am not averse to using photographs as a reference source or as the basis of a collaged scene.

## Painting from life

Flowers give you considerable scope, and the projects in this book show you several different types of composition.

Still-life arrangements of flowers in a vase are very popular. However, some flowers with large single blooms lend themselves to being painted life-size or even bigger. Others, especially those with smaller individual flower heads, appear best when painted as a group. Finally, you can use flowers as the major part of a landscape.

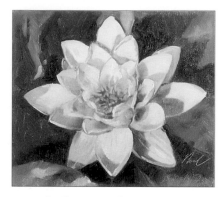

*A single flower study*
*This water lily is an excellent subject for a single flower study. The simple shape of the petals makes it ideal for painting larger than life and I purposely enlarged it to cover the entire canvas area for the first project on page 20.*

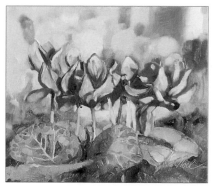

*A group of flower heads*
*Cyclamen, with their small but highly sculptured petals, need to be seen as a group. At first, they appear to be quite complex but, as you will see in the project on page 22, they can be treated as lots of simple shapes.*

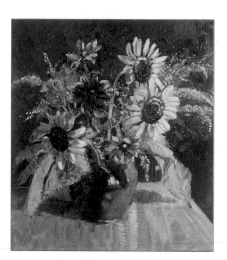

*A still-life arrangement*
*Why do so many still-life flower studies in pots look like 'Van Goghs'? This was not my intention when I painted this project, but it seems to have worked out this way. The secret for this type of composition is to keep things simple. There are two basic rules: do not put too many different types of flower in the group; and do not include too many colours.*

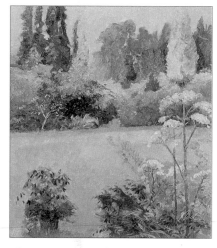

*Flowers in a garden*
*Flowers in the garden provide an endless source of subjects. Treat this type of painting as you would a landscape, removing any unsightly objects and adding points of interest. For this particular scene, I 'imported' the flower pot at bottom left to balance the composition. Alternatively, I could have added some flowers, painted from cut stems, to this part of the foreground.*

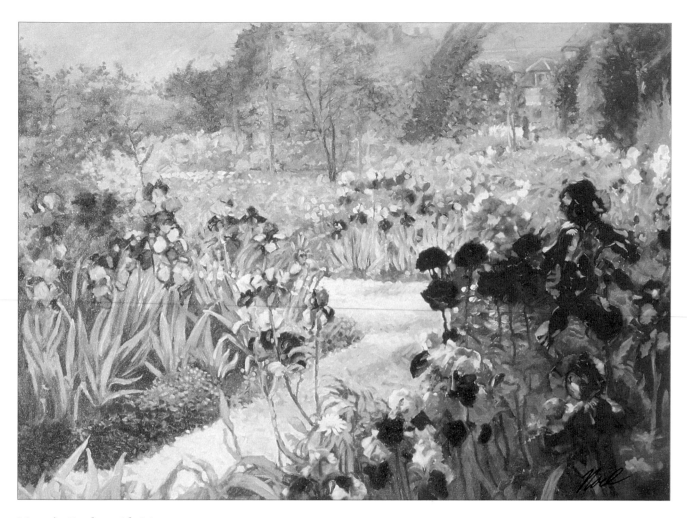

### Monet's Garden with Irises
*Size 915 x 660mm (36 x 26in)*

*Monet's garden is a great source of images for any painter. He managed to put any old flower colours, shapes and species together without losing the sense of composition. You can also add extra flowers, as I have done here, if you need more colour in the foreground.*

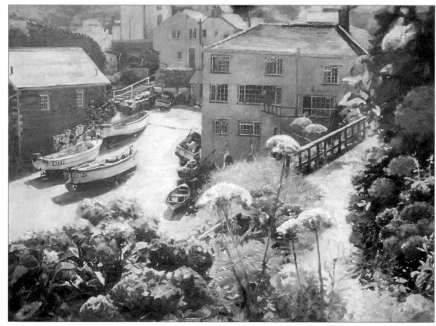

### Cornish Village
*Size 915 x 685mm (36 x 27in)*

*This is my favourite place, Portloe, in Cornwall. I added more hydrangeas in the foreground to make a frame for this composition. The scene is attractive enough without these flowers, but the colour perspective of the warm pinks against the blues of the background adds depth to the scene.*

# Composing with photographs

I often use photographs when painting flowers. Sometimes, I use a single photograph as a straightforward reference source, other times, I cut up several photographs to create a pleasing composition. Photographs provide an easy way of tackling perspective, especially if you add a grid to help you transpose the composition on to the canvas. When making a collage from photographs, remember that everything must be scaled correctly.

Taking your own photographs would be the most personal, but there is nothing to stop you from using illustrations from books or magazines. I keep a scrapbook containing photographs, sketches, cuttings from gardening books and magazines and reproductions of painted flower studies. In fact, I save anything that might prove interesting in the future.

There do not have to be flowers in the original scene, just places for them to look natural. If your picture would benefit from, say, delphiniums, you can add them to the scene, either painting them from life or from references in the scrapbook.

Here I show you how to create a simple composition from three separate photographs taken at the same location. The photograph of the country lane lacked detail at the left-hand side, so I cut out two close-up photographs of rhododendron heads and placed these in the foreground to produce a strong sense of perspective.

1. Cut round the outline of the parts of the photographs you want to include in your composition.

2. Move the component parts of the scene around until you are happy with the composition.

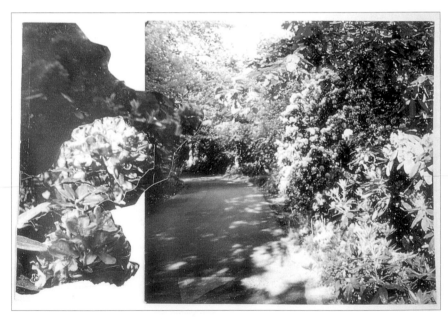

3. Stick the pieces of photographs on to a sheet of card or paper.

4. Draw a grid of equi-spaced horizontal and vertical lines on the collage. Transpose this grid, to either a larger or smaller scale, on to the canvas, then use the grid to sketch in the main outlines of the composition.

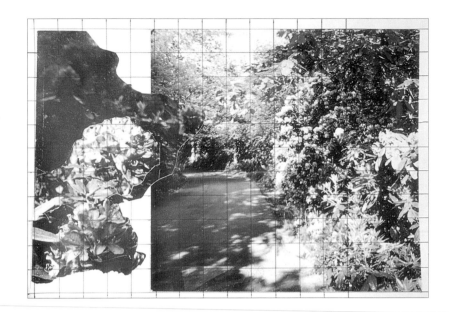

**Rhododendron Lane**
*Size 760 x 610mm (30 x 24in)*
*The finished painting. When I came to paint this scene, I felt that it was not well balanced so I made the painting squarer by cropping out some of the foliage at the right-hand side.*

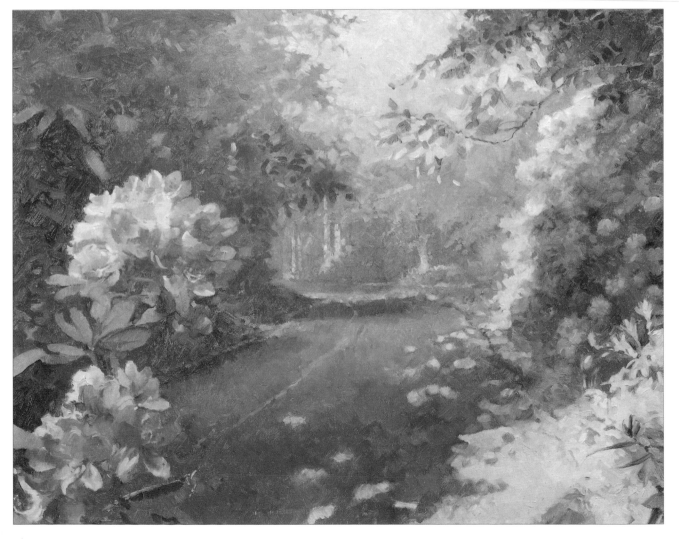

# Water lily

I have chosen a single water lily as the subject for this first step-by-step demonstration. Apart from being one of my favourite subjects, the water lily is made up of very simple shapes and the petals contrast well against the natural background. A strong light source, giving plenty of shadows, is essential for this type of study, as subdued lighting will make the flower appear flat and difficult to understand. The tonal contrast between the background and the flower head is also very important. Looking at the subject through half-closed eyes will emphasise this contrast.

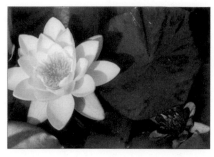

*I painted this demonstration under the artificial lights of a photographic studio, so I used a photograph for reference. Notice that for the actual composition, I rotated the flower slightly.*

1. Use a weak colour and a small brush to draw in the overall shape of the flower head, sizing it to fit the canvas. Keep everything as simple as possible.

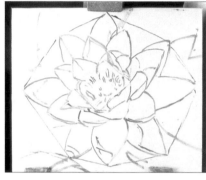

2. Now draw in the outlines of individual petals and any leaves. Do take time to ensure that you size everything correctly.

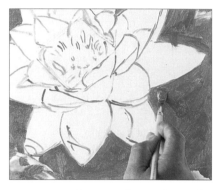

3. Use viridian, with touches of ultramarine and burnt umber, to block in the background.

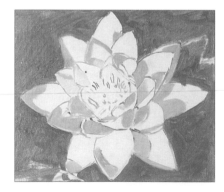

4. Add titanium white and a touch of cadmium red to the green mix, then block in the shadowed parts of the petals.

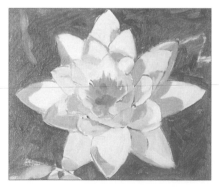

5. Mix cadmium yellow and cadmium orange, then block in the flower centre. Add titanium white and a touch of cadmium red, then block in the petals.

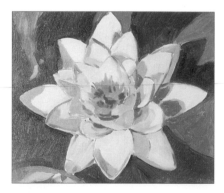

6. Introduce touches of ultramarine and ivory black to the mixes on the palette, then use these tones to establish the dark areas of the painting.

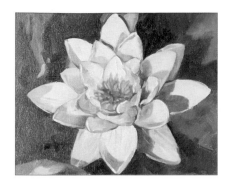

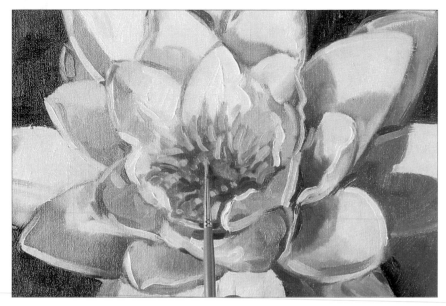

7. Now, blend and work the colours together, correcting the shapes as necessary. This stage can take a considerable time to complete, and you may need to add more touches of colour to redefine some shapes.

8. Finally, use a fine round brush to add fine detail to the flower centre, and small highlights on the petals.

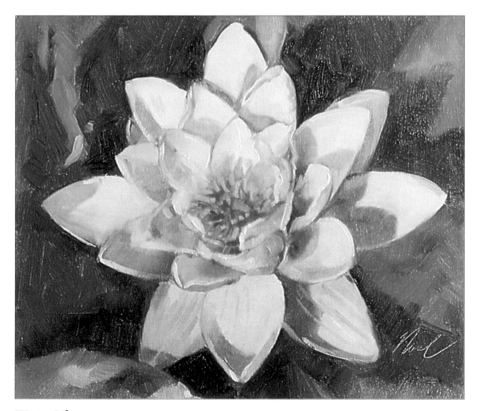

**Water Lily**
*Size 255 x 215mm (10 x 8½in)*

*The finished painting. Simple uncluttered flower head studies such as this often produce the most exciting paintings. They can be great fun to do, especially if you paint them much larger than life as I did with the painting of the hibiscus flower on page 24.*

# Cyclamen

For this next demonstration I have chosen to paint a plant with multiple flower heads – a composition where the background and environment have to be taken into consideration. This cyclamen in a pot is an excellent subject to paint, but rhododendrons, hydrangeas and lupins are all suitable subjects

When setting up your subject, always try to keep it and the canvas in the same line of vision. This will minimise the movement of your head and body, and you will find it easier to transfer the shapes on to the canvas.

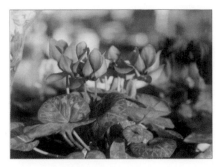

*Reference photograph.*

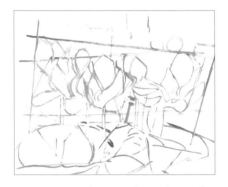

1. Draw in the rough outline of the whole group of flowers to fit the canvas, then add detailed outlines for the petals and leaves. Here, I have purposely used one colour to show the rough outline, and another for the detailed drawing.

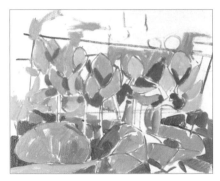

2. Block in the basic shapes of the petals and leaves.

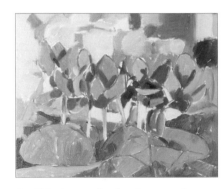

3. Work up the background area of the composition.

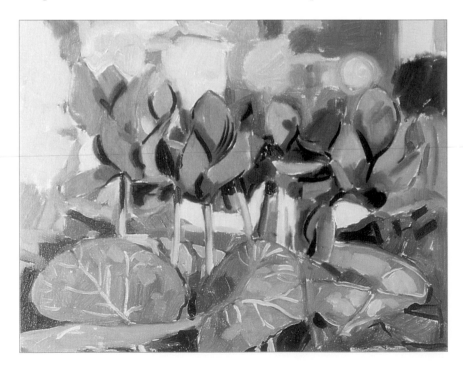

4. Start to redefine shapes, adding more colour and mixing colours on the canvas.

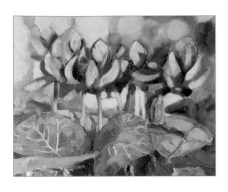

5. Accentuate the highlights, mid tones and shadows.

6. Finally, add small details with a fine round brush.

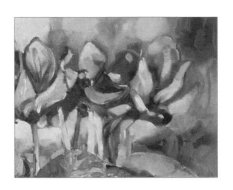

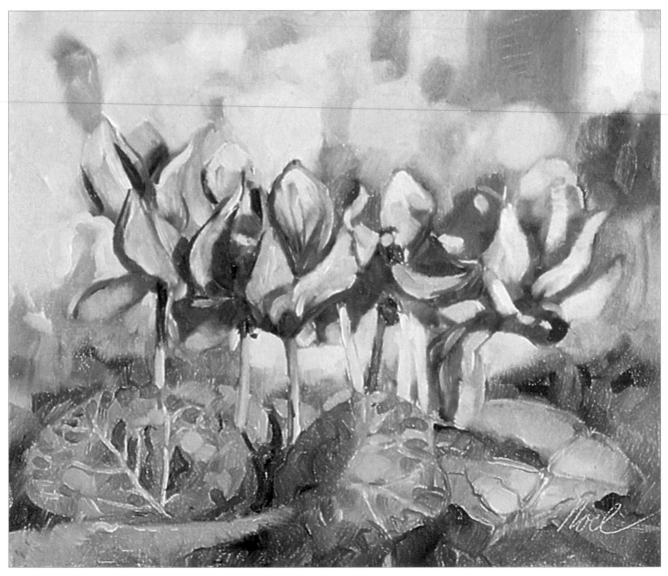

*Cyclamen*
*Size 255 x 215mm (10 x 8½in)*
*The finished painting.*

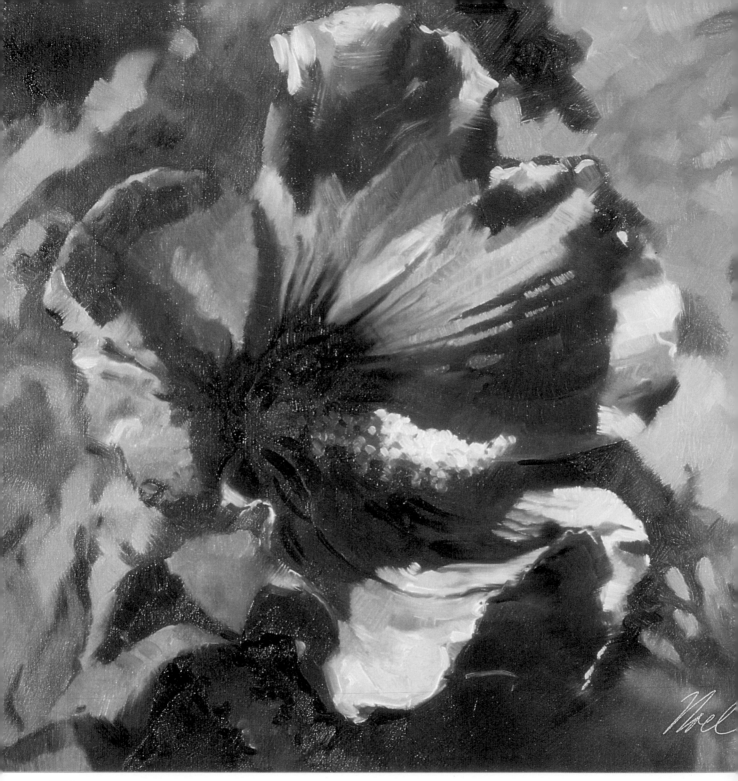

### Hibiscus

*Size 510 x 510mm (20 x 20in)*

This was an exciting subject to paint because of the enlarged scale. Its very size grabs your attention. Try this larger-than-life technique yourself and you will soon discover that you must really look at the flower to see all the subtleties of shape and colour that the flower possesses.

24

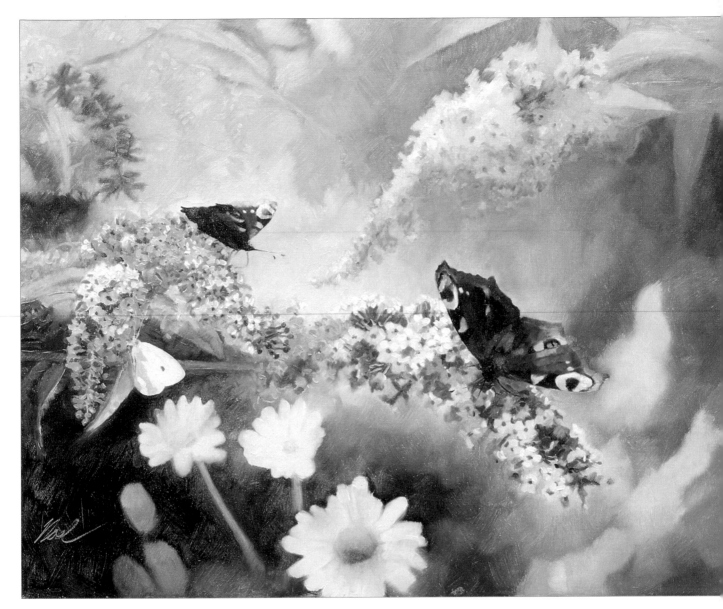

## Buddleia

*Size 510 x 405mm (20 x 16in)*

*Buddleia is one of the plants favoured by butterflies, and it is often grown just to bring these colourful creatures into the garden. So, for this composition I made the butterflies the focal interest. Such subjects still demand detailed work on the flowers themselves and I painted these from life in my studio. The butterflies were added from reference photographs. The technique of depicting some of the background flowers as being out of focus is not as difficult as it may first appear. When all the flower heads had been completed, I allowed the paint to dry slightly then lightly dragged a dry clean brush across the areas I wanted to appear soft. You have to learn by experience about how long to leave the paint to dry – if it is too wet or too dry, you may be disappointed.*

# Still-life composition

A vase of flowers is an obvious pictorial idea, made famous by the works of Vincent Van Gogh. His familiar images were of simple compositions with a table, a vase and an arrangement of flowers. There are no defined rules for such still-life studies other than the basic idea that if the arrangement is well balanced and looks right, it will make a good painting. However, here are a few tips that will help you set up a simple arrangement.

Do not overcrowd the arrangement. Do not use lots of different flower shapes. Try to use flowers that have similar colours. Always arrange the stems to look as natural as possible rather than forcing them into contrived shapes.

Choose a vase that complements the flowers in both colour and shape, and one that is tall enough to support the stems. If the vase has a complicated shape it will take the eye away from the flowers.

Light the arrangement well from one side to give bright highlights and deep shadows. Not only does this give you a better composition but the painting will prove easier and more exciting to do.

Finally, carefully consider the placement and size of the flowers and vase on the canvas – too small a subject will require a greater degree of composition of the background.

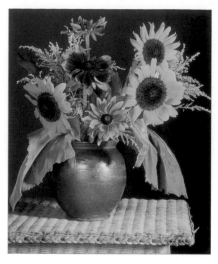

*This still-life composition works because it has a limited colour range and not too many different flowers. A good light source from one side provides lots of tone and shadows to add more interest.*

1. Use a pencil or a small brush to sketch in the basic outlines of the composition. At this stage, concentrate on establishing the overall shape and size of the composition relative to the size of the canvas.

2. Now, keeping things very loose and sketchy, start drawing in the shapes of the individual blooms and leaves. If you make a highly detailed drawing, you may be tempted not to paint over the good bits.

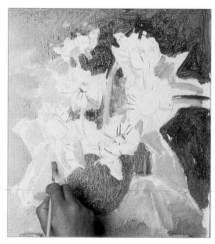

3. Block in the dark background, roughly following the drawn shapes of the flowers. Block in the table and vase, then start to block in the larger leaves.

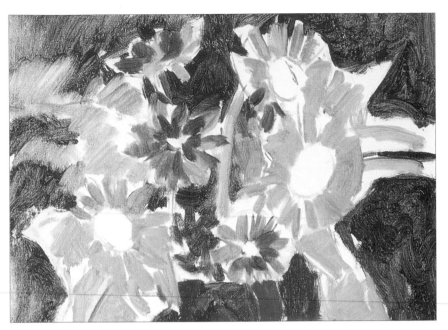

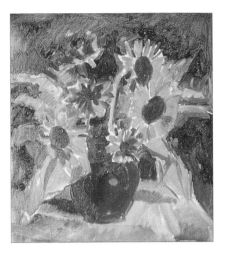

5. Fill in the flower centres, then develop the rest of the foliage until the canvas is completely covered with paint.

4. Roughly block in the flower heads. Cover the canvas as quickly as possible, for it is only then that you can judge the exact colour and shape of your subject.

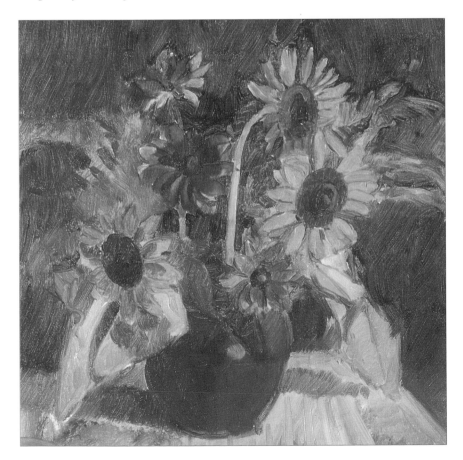

6. Start to work on shadows and highlights, mixing colours on the canvas. Add small touches of white to the lighter areas and touches of ultramarine to the shadows. This is one of the best aspects of painting with oils – as long as the paint is still wet, you can work colour into colour as much as you like.

7.  This stage is all about moving and mixing the colours on the canvas, as well as the palette. Experiment with different brushes to get a change of texture. Start working smaller areas of the canvas, adding more detail and softening other areas with a dry brush. This is where you start to develop your individual style.

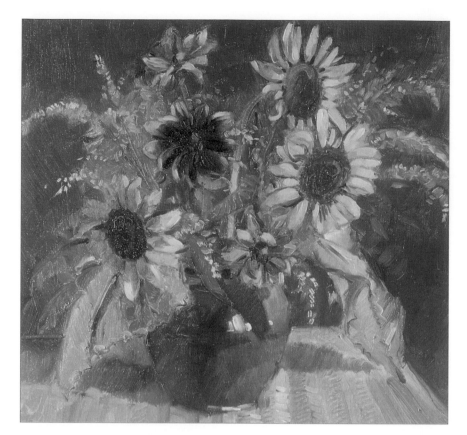

8. Finally, use a small round brush to start refining the smaller flowers and adding tiny details. Remember that knowing where to stop is as hard to learn as where to put the first brush strokes.

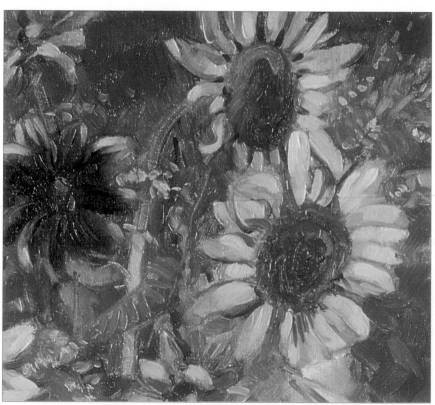

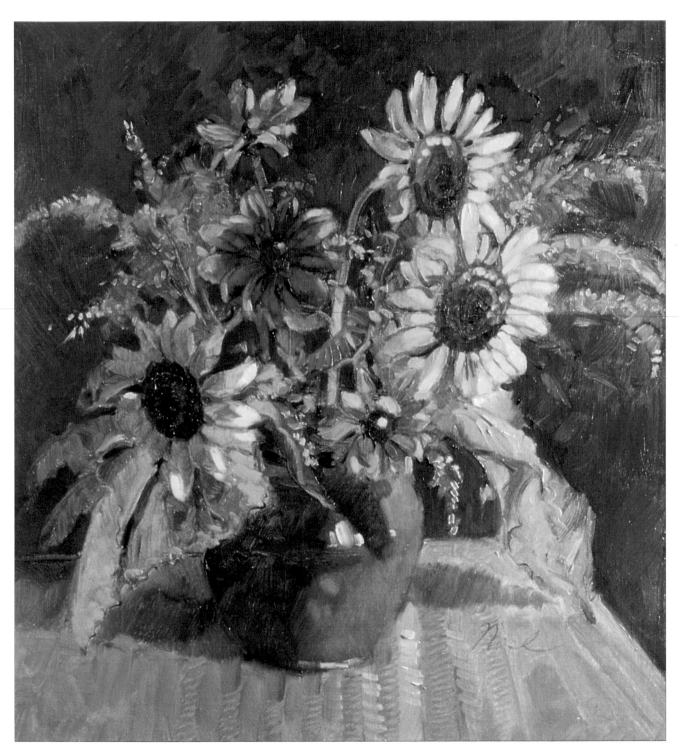

**Sunflowers and Rudbeckias**
*Size 305 x 345mm (12 x 13½in)*

*The finished painting. Step-by-step demonstrations, especially in a photographic studio, do not always run smoothly. Here, the heat from the lighting system gradually made the flowers droop lower and lower. Holding up individual flowers in one hand and painting them with the other is a hazard not to be recommended!*

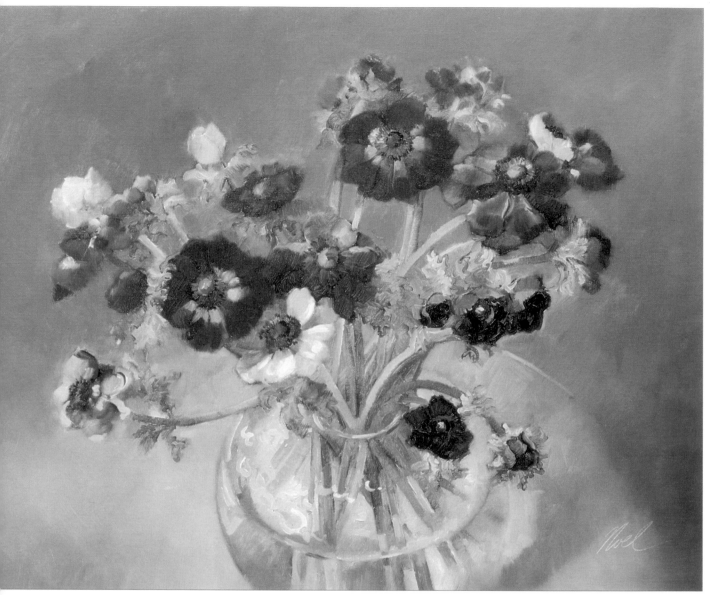

**Anemone Bowl**
*Size 405 x 330mm (16 x 13in)*

*Anemones are a pure joy to paint, as their very vibrant colours make them an excellent subject. The addition of the clear glass bowl provided that extra interest, but every angle of the flower stems had to be correct for the water to look right. Painting glass can be a little daunting, but it becomes easier if you give yourself a little time to see all the reflections properly. Try standing a single stem in a small jam jar, light the subject from one side, then copy all the reflected areas by reducing them to very simple shapes.*

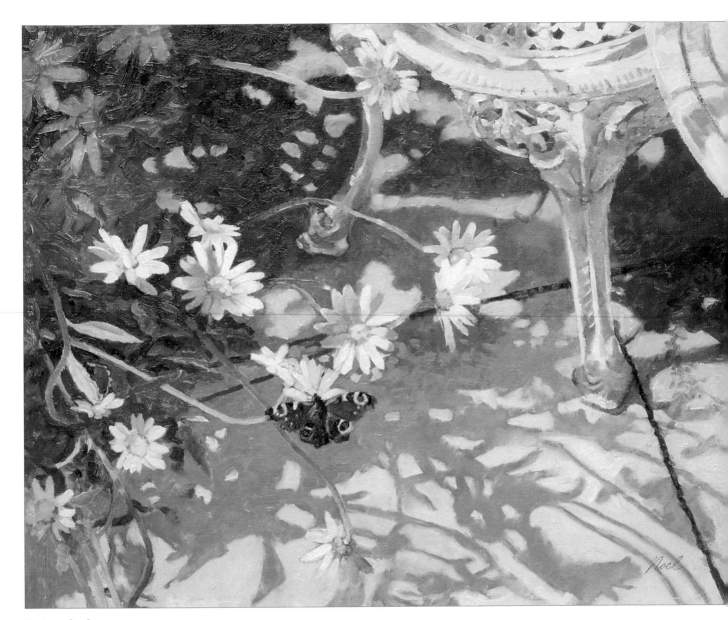

## Daisy Shadows
*Size 405 x 330mm (16 x 13in)*

*You can come across subjects to paint at any time. One sunny morning, while taking breakfast in my garden, I saw these fascinating shadows cast on the ground by some daisies and decided, there and then, to commit them to canvas. The bright butterfly was included to provide a colour contrast to the blue greys of the composition. By using complementary colours in this way, both ends of the spectrum are intensified.*

# Flowers in a garden

Now we come to my favourite subject – painting a garden scene where flowers are a secondary, but nevertheless very important, part of the composition. Perspective is an important factor in this type of painting, and for many this will be a worry. However, take things one step at a time and do not be put off. Perspective is just a man-made formula for making three dimensional objects look right in two dimensions.

In this project of a garden in Sussex I show how to 'sight size' measurements and angles. Sight sizing is the method of reducing shapes and objects to the size they appear at arm's length when viewed through one eye. The height of a tree, for example, is measured by aligning the tip if a paint brush with the top of the tree, then sliding your thumb down the brush until it aligns with the base of the tree.

Sight sizing is a very easy technique to learn, and you will soon master the most complicated scene, even if your understanding of perspective comes later.

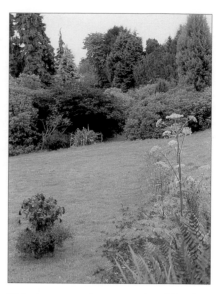

*This demonstration was painted in situ – with several 'rain-stopped-play' interludes – but I have included this photograph to show you my viewpoint.*

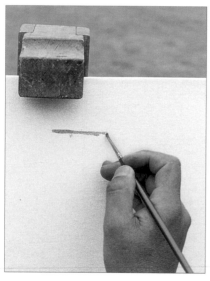

1. Roughly sight size the whole area you want to include in the painting, then draw a line to represent the top of the far trees.

2. Sight size the vertical distance between the top of the trees and the far edge of grass. Transfer this measurement on to the canvas, draw a horizontal line to represent the edge of the grass.

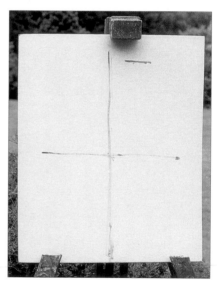

3. Draw a vertical line down the centre of the canvas. Although this is an imagined line, that does not appear anywhere in the scene, it helps you to place objects relative to each other.

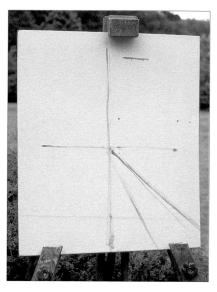

4. Sight size the angles of the top and bottom edges of the low wall . . .

5. . . . then transfer these on to the canvas.

6. Sight size from the far edge of the grass to the bottom of the planter, then transfer this measurement on to the canvas.

7. Continue sight sizing all the major shapes and transferring them on to the canvas. Complete the sketch by filling in the outline shapes of each component.

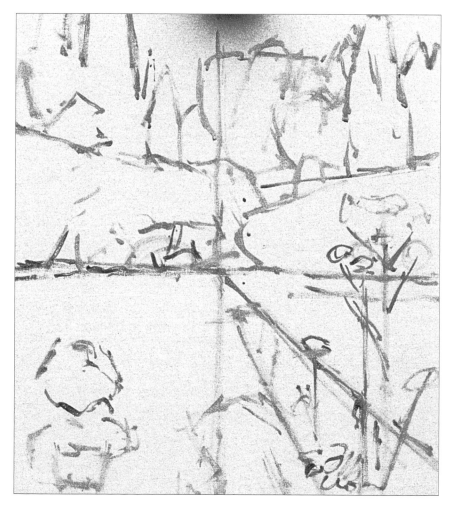

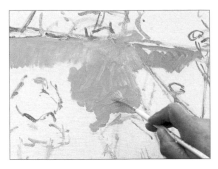

8. Mix a mid green, then start to block in the area of grass.

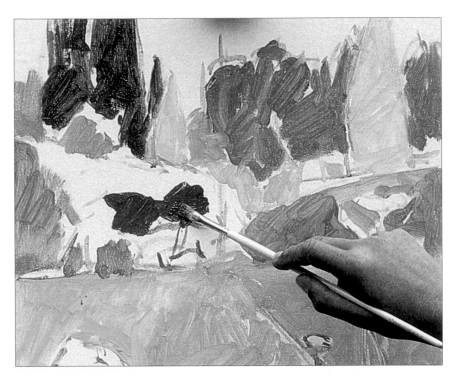

9. Add more yellow to the mix then block in the right-hand fir tree. Mix some dark greens, then block in the basic shape of each cluster of trees and shrubs. Add a touch of red to the green mixes, then block in the brown area of the acer bush.

10. Add white to the brown mix, then add highlight to the acer. Use this mix to suggest the low wall and the planter in the foreground. Finish blocking in the remaining green parts of the canvas, then use almost neat cadmium orange to indicate the mass of montbretia flowers. Use ultramarine for the blue lobelia in the planter, then add white with a touch of cadmium orange for the sky. Add a touch of cadmium yellow to indicate the flower heads on the wild angelica.

11. Add sky windows in the tree shapes, then redraw the outlines of each tree shape by developing the sky line.

12. Picking up colours from the canvas and adding small touches of fresh paint, start to redefine shapes and depth. Use a clean brush to blend and soften the colours. Keep the brush clean by continually wiping off excess paint with a rag.

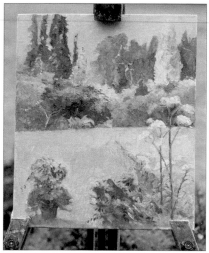

13. Continue defining all the shapes on the canvas, gradually working on smaller areas and adding finer details.

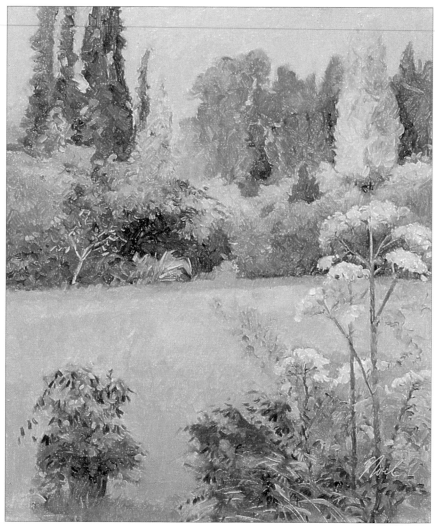

*Sussex Garden*
*Size 305 x 370mm (12 x 14½in)*
*The finished painting*

# Gallery

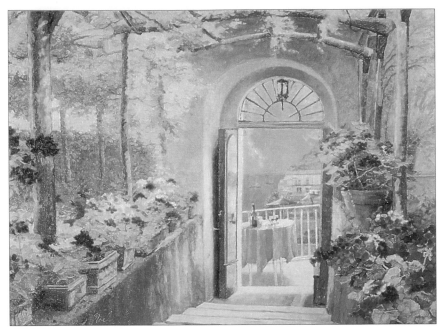

**Mediterranean Door**
*Size 815 x 610mm (32 x 24in)*

*This scene could be almost anywhere in the Mediterranean. The red flowers of geraniums always contrast well against the complementary colour of their green leaves. This painting was created from a photograph with added still-life flowers. The view through the open door is totally imagined, although the table with the bottle of wine and glasses was set up and floodlit in my studio.*

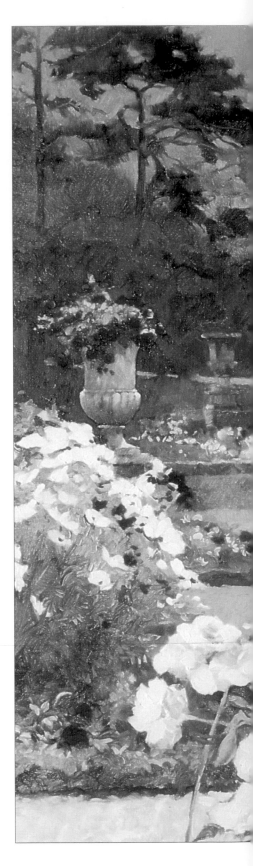

**Parisian Garden**
*Size 1270 x 1065mm (50 x 42in)*

*The basic composition for this large painting was taken from a book illustration. However, to make it more personal, I used several reference photographs to add some of the flowers. I made up a collage of images, using the method described on pages 18-19, then painted the picture. Working this way means you can spend as long as you like on a painting without worrying about the weather conditions.*

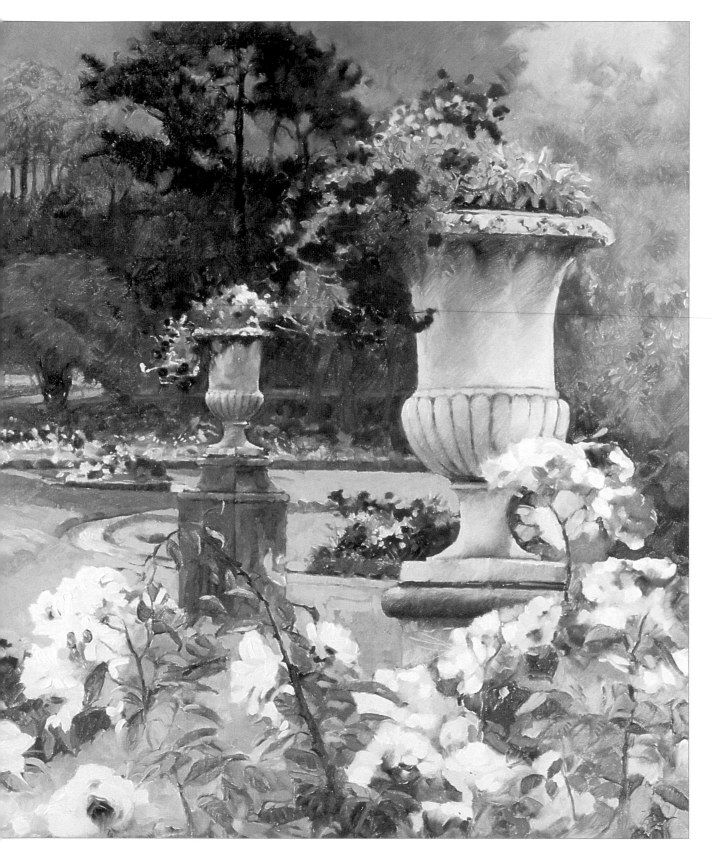

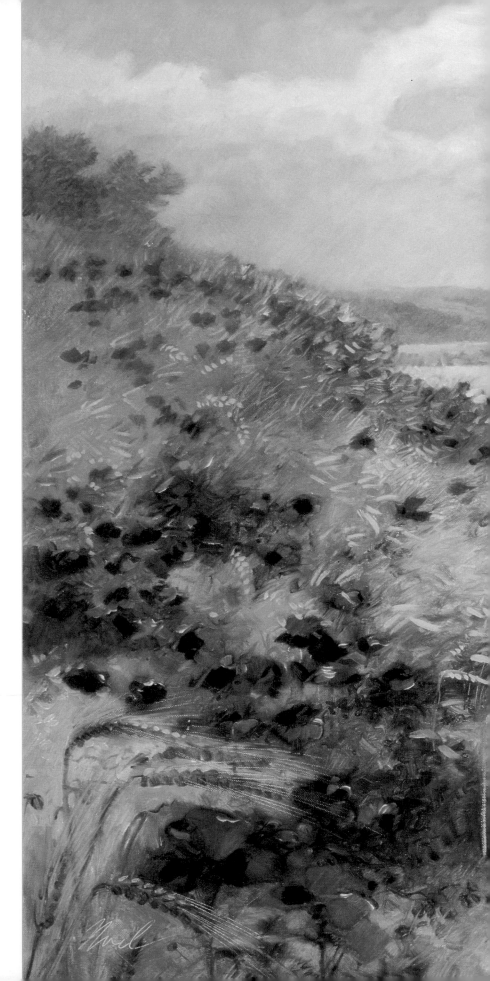

## Poppy Path

*Size 965 x 760mm (38 x 30in)*

*This is a picture that developed gradually, rather like completing a crossword puzzle. It started when I found the blue cornflower, which for some reason is not as common as it once was. I painted this on a large canvas, then added the poppies around it from life. I then developed the picture by adding more and more flowers and the path. I only stopped building up the composition when it seemed to be well balanced. This is not the easiest way to go about painting pictures, but it is great fun.*

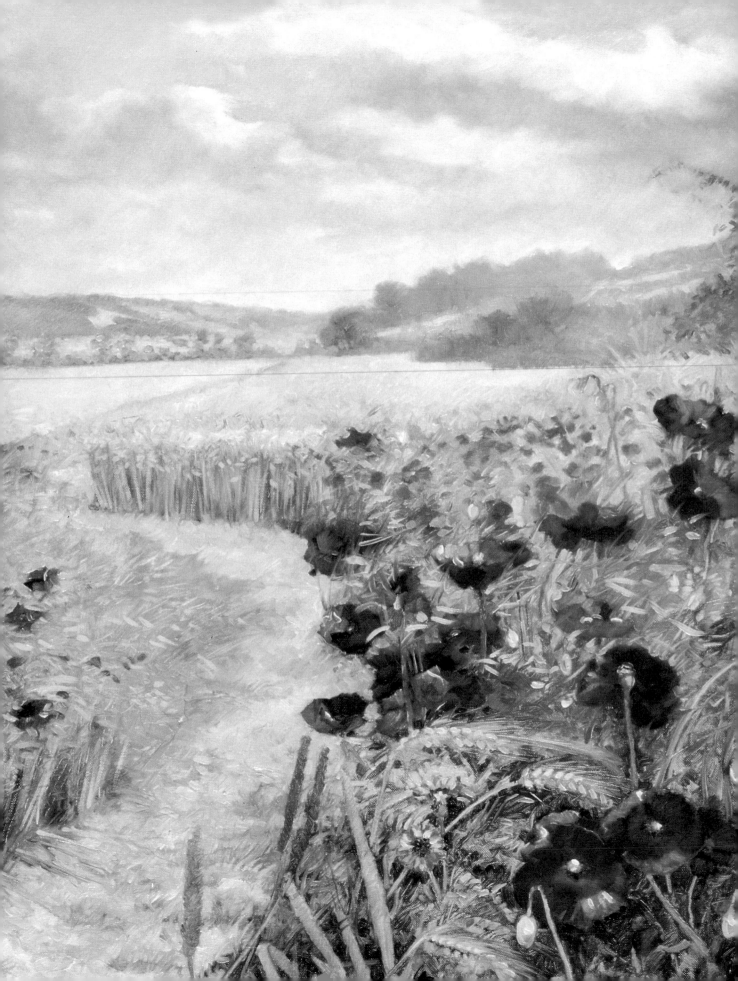

### Monet's Garden

*Size 965 x 760mm (38 x 30in)*

*Monet's garden at Giverny has foxgloves around the lake, but not exactly as shown in this painting. I painted the garden* in situ, *then took it into my studio where I added the foxgloves, working from a still-life arrangement of a few stems in a vase. The slightly misty appearance of the background is the result of overpainting with a weak wash of white mixed with linseed oil. This technique also gives more depth to a painting, but such washes must only be added after the original layers of paint are completely dry. Try experimenting with other thin colour washes and note how the wash links together unrelated hues.*

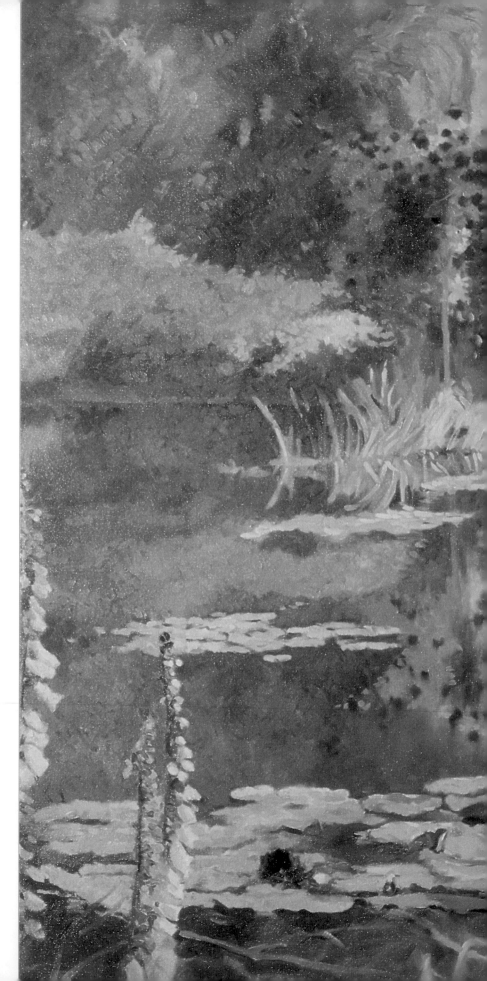

40

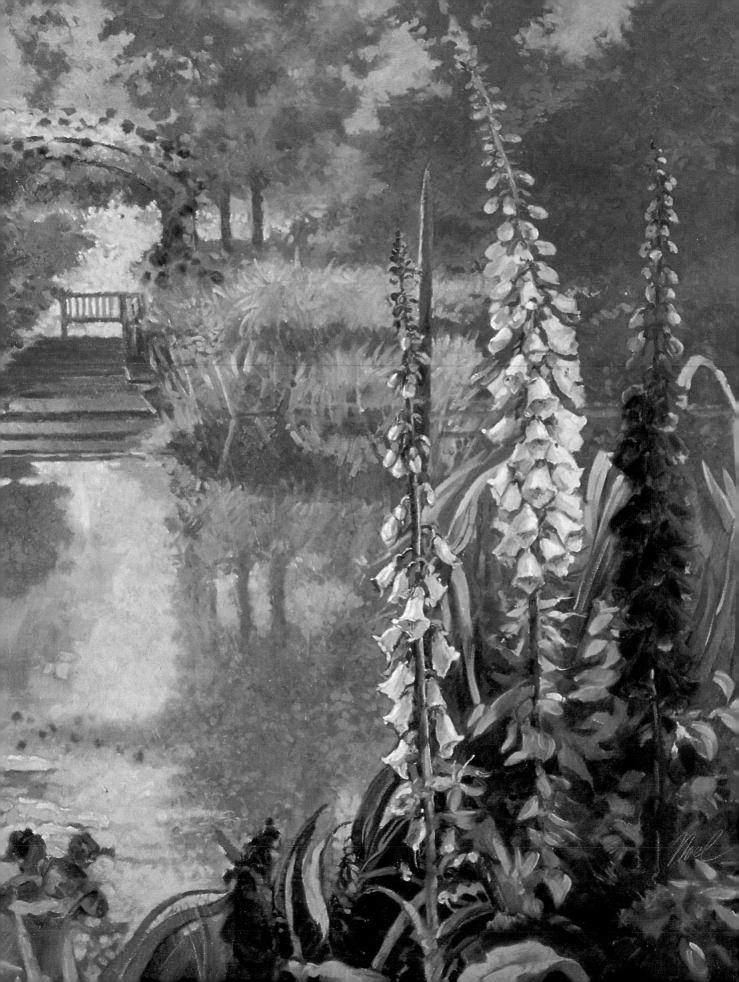

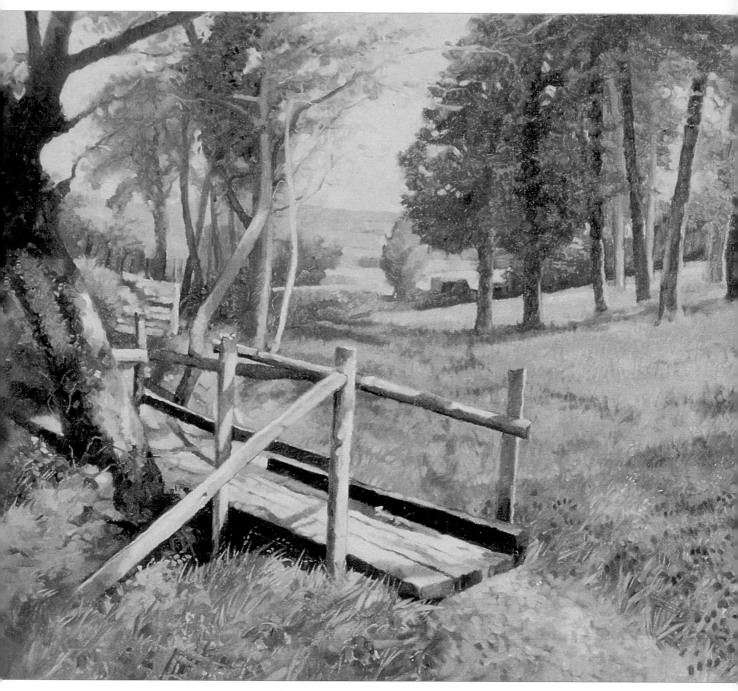

**Bluebell Bridge**
*Size 760 x 510mm (30 x 20in)*

*This scene is a few minutes walk from my home, so I have painted it several times. However, the bridge is not actually in the position shown here; I moved it somewhat so that it leads the eye into the composition. There are no rules about moving objects within a composition if you feel that they will provide added interest.*

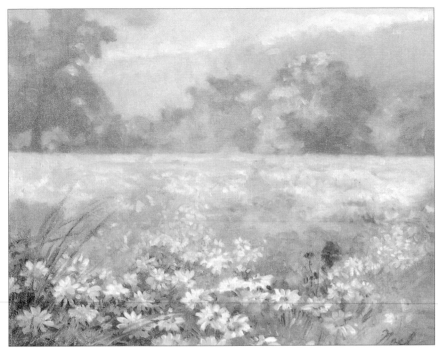

**Daisy Field**
*Size 405 x 320mm (16 x 12½in)*

*This painting is another success created from a failure. Originally, it was part of a very much larger canvas that contained too much uninteresting detail. It was transformed by cutting it down to only a fraction of the original size and adding a single red poppy. Again, there are no rules to follow, and you can do this to any picture that you are unhappy with. Give yourself time to see the mistakes in an unsatisfactory painting, leave it alone for weeks if necessary. You could also try looking at the painting in a mirror so that the image is reversed – you will be surprised how mistakes become obvious.*

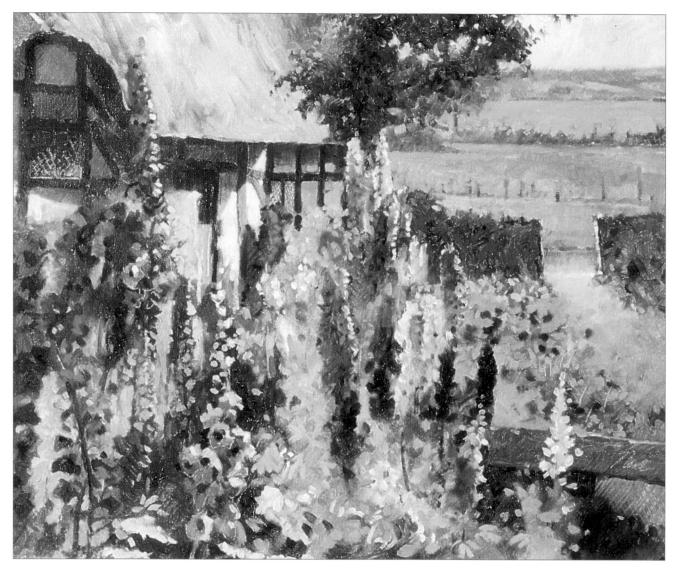

**Ann Hathaway's Cottage with Delphiniums**
*Size 485 x 405mm (19 x 16in)*

*I used the same reference photograph of Ann Hathaway's cottage as the main subject
for both this painting and the one opposite. As artists we can change anything to
make a well balanced and interesting composition. Here, I decided to add a large
clump of delphiniums in the foreground. I cut a few stems, placed them in a large
vase then painted them to look as if they belonged to an herbaceous border.*

*Opposite*
**Ann Hathaway's Cottage with Clematis**
*Size 760 x 990mm (30 x 39in)*

*This painting is really a study of clematis, taken from a photograph that I found in a
gardening book, and the same photograph of the cottage used for the painting above.
Collaged compositions such as these illustrate the advantage of using photographic
references. The cottage never looks like this, but one feels it could.*

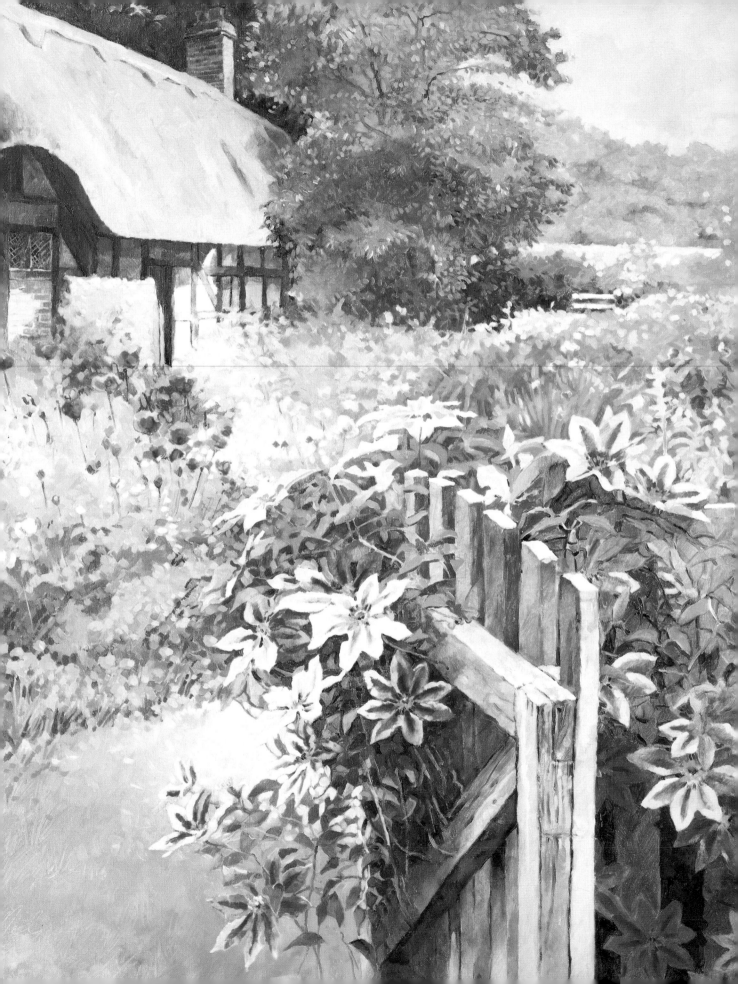

## Tiptoe Through the Tulips
*Size 610 x 405mm (24 x 16in)*

This painting is a personal favourite of mine. It has an interesting background which I hope will prove inspirational if things go wrong with your paintings. Originally, I started painting a bed of tulips as a 'plein air' on-the-spot study. The weather changed, so I took some reference photographs and continued work on the piece in my studio, but the painting (right) was never completed. I disliked it so much that I hid it away for many years. Then, when I looked at it afresh, I thought that one of the flowers had potential. I started reworking the canvas and my great love of ducks led me to include some in the composition. Not only did the picture improve beyond all recognition but the image became a very popular greeting card. So, my advice is to keep all your paintings, even if you hate them, for one day you may be able to change a failure into a success.

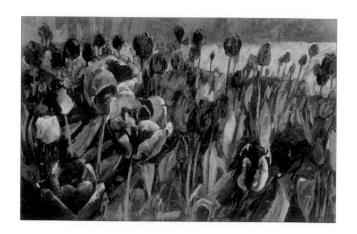

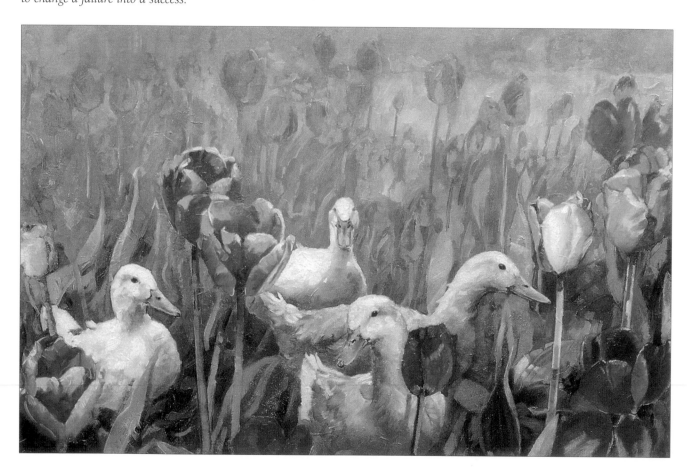

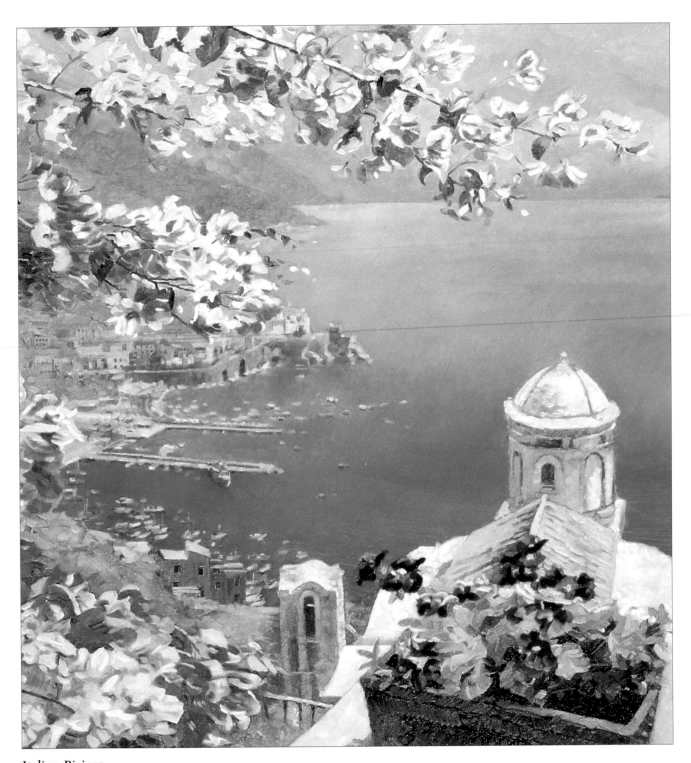

**Italian Riviera**
*Size 245 x 280mm (9¾ x 11in)*

*This famous view actually has a tree in the foreground but, as I am an artist and not a
photographer, I elected to replace it with a bougainvillea. The composition then became a
flowers-in-the-environment painting instead of just a picture postcard. Remember that
you can change anything you like, as long as the addition is scaled correctly.*

# Index

## Primroses

*Size 255 x 205mm (10 x 8in)*

*This little study shows how attractive a limited colour image can be. Try to look at all flowers as simple shapes even if they contain the most complicated array of blooms and detail. Flowers can be the most rewarding of subjects and they will teach you a great deal about colour mixing and tone. I wish you every success with them and hope you enjoy painting them as much as I do.*

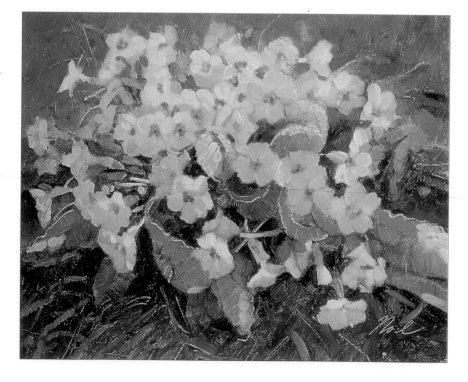